SOUL SONGS

Volume 1, Issue 2

Executive Director of S.O.U.L., Ginger B. Wiechers

The Soul Community House is located at:

32905 Grand River Ave
Farmington Michigan
48336

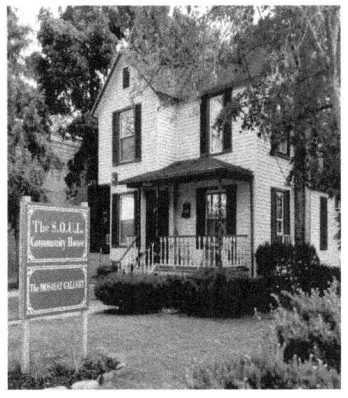

Ginger B. Wiechers...Life Coach and Spiritual Counselor. As a life coach she integrates and shares the knowledge and wisdom developed over many years as an entrepreneur and business leader. She is skilled in the food industry as owner of Ginger's Coffee Connection for twenty years and Ginger's Café of Farmington for an additional five years. Ginger also created an investment company and is savvy in both residential and commercial properties. In one of the Farmington commercial properties she developed a Mind, Body, Spirit Center. She and other dedicated professionals are devoted to wellness through a natural and spiritual approach. Nearly a decade ago, Ginger created and became the executive director of S.O.U.L. (Source of Universal Love), a 501(C)3, non-profit organization dedicated to helping those in need. This organization helps transform the lives of individuals and families in adverse situations. The goal is to respond with love, respect and provide the resources available, as needed. Some of the ways S.O.U.L. assists includes providing food, clothing, household goods, furniture, education, transportation, care counseling, comfort and compassion. Four years ago S.O.U.L. expanded to included "SOUL for Animals" bringing awareness to the need of animals and to be a reminder of gratitude for the extraordinary role animals play in our lives. The most recent addition to the list of achievements is the SOUL Community House and Mosavat Gallery. This building houses the Soul Collective of Collaborative Arts (S.C.C.A.), whose mission is to bring aspiring and established artists in all disciplines together to support and make a lasting difference in the lives of those who are assisted by S.O.U.L. The Mosavat Gallery honors the life and work of Hosain Mosavat and his wife Judy and their many contributions to SOUL. The common theme in all endeavors is to serve and empower others.

Email: scca59@gmail.com
soul_nonprofit@sbcglobal.net
Website: www.sourceofuniversallove.com

Soul for Animals

S.O.U.L. is not just committed to helping humans in need. They are also passionate with regard to helping our furry friends as well.

S.O.U.L. believes that animals are unconditional love. They provide comfort, joy and companionship. Pets are examples of loyalty and devotion. Often an animal is truly a best friend to the lonely, elderly and ill. Animals give so much and ask so little. S.O.U.L. is dedicated to bring awareness to the need of animals and to be a reminder of gratitude for the extraordinary role animals play in our lives.

♥ Please contact us if you know of an animal in need. S.O.U.L. for Animals is looking for foster families to temporarily provide love and care. We are also grateful to receive donations of food, toys, other related supplies and gift cards for veterinary care and grooming. Monetary donations are welcome and can be made on our website.

http://sourceofuniversallove.com/

SCCA Seeking Creative Minds

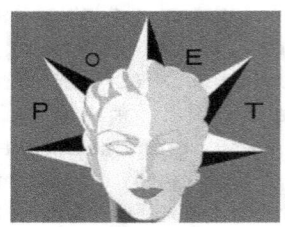

The Soul Collective of Collaborative Arts (S.C.C.A.) in association with The Source of Universal Love, (S.O.U.L.) Seeks, Writers, Poets, Photographers, Artists, Musicians, and all others in the creative arts to join our collective of creative minds.

The S.C.C.A. exists for you, the artist.

We hold events, meetings, and fundraisers to further the arts in Michigan, and seek local and regional artist to become members of our collective.

The S.C.C.A. operates under the auspices of S.O.U.L., a 501(C)3 non-profit organization.

S.O.U.L. helps those in need, and the S.C.C.A. works creatively and in partnership to further that mission via creativity, collaboration, and artistry.

For further information, please contact us at:

scca59@gmail.com,

or visit the S.O.U.L. website at:

http://sourceofuniversallove.com/

**S.C.C.A.
THE ART AND SOUL OF CREATIVITY**

Come join us!

The Mosavat Prize for Excellence in Poetry

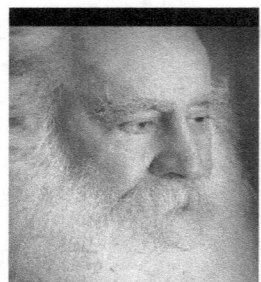

On an annual basis, a cash prize and membership to The S.O.U.L. Collective of Collaborative Arts will be awarded to one individual that exemplifies the craft of poetry in fresh and unique forms.

In addition, winners will be given a guaranteed spot in the organization's annual anthology of poetry.

Entries are limited to three poems per candidate.

Judging of entries will be performed by staff members of "The S.O.U.L. Collective of Collaborative Arts. Entry fee is $10.00

Send all entries to:

S.C.C.A.,
c/o Source of Universal Love
P.O. Box 5
Farmington, Michigan
48332-0005

Local, Regional, and International Artists

In case you may have thought that the Mosavat Gallery was just a local destination, I would, with all respect let you know that in addition to local art works being displayed and sold here, we also are privileged to have several works in our collection from around the country.

These include works by Michael Indorato, Christopher Edmondson, Paul Sonnenberg, and IS.

We also have Photographic works by Hosain Mosavat, and Viviana Podina.

To walk through the gallery and view these works is a journey through the imagination of each artist whose richness of colors and artistic vision leaves one to wonder if they have stepped into a blessed room of Nirvanic joy.

Each piece is unique and within this current collection of over 40 pieces of art, patrons will find something that will speak to their very souls.

Prices range from fifteen dollars to six hundred dollars, and a portion of all sales will go directly to benefit our parent charity, S.O.U.L. Source of Universal Love.

The Mosavat Gallery sells art pieces that come in price ranges fit for all, starting at $15.00 and up

More about Christy Pardee, June's featured Artist

Regarding formal art training, she states,

"I did figure drawing courses at Wayne State in the late nineties while I pursued my Psychology Bachelors. Then, when I went to New York City for ten years, I took courses in comic book drawing at the School of Visual Art. Also while in NYC, I had my solo show at Bluestockings Women's Bookstore in Manhattan. My watercolor work is self-taught. I did a three year stint at College for Creative Studies in Detroit in the Illustration Department (2010-2013), this is where they recommended I combine my Psychology Degree (class of `98) and art skills, and go to the Art Therapy Master's Program at Wayne. I am a second year student there currently. Art Therapy has had an amazing impact on my work, allowing me to express deeper emotions."

Christy Pardee

Azure Hues
(A poem by William Burkholder)

Hands raised to meet the sky, she prays for peace and healing. Under clouds of azure hues imbued in the embrace of serenity.

'Tis no lament, nor cry this day.
Simple peace and joy the way.
She calls upon humanity
to finally open its eyes,
And put asunder doubts,
and personal alibi.
Seek the truth
and see yourself,
in reflective pools dancing.
With hands raised up and celebrating
clouds of azure hues.

*Art is the culmination of passion brought to life. It is the rendering of all things beautiful.
W.B. Burkholder*

SOUL SONGS

If you are not writing, you should be.
The pulse of the world exists in the writer's ink.
The collective breaths of a society...

Share your thoughts

Share your words

Share your dreams

Let the pulse of your spirit fall upon the page

Share your Words

The Pulse of the world Exists in the Writer's ink.
Let the rhythm of your spirit fall upon the page.

Have you taken the time today, just a few moments to convey your thoughts through writing? Whether its poetry, prose or just a journal entry, the craft of writing is an affordable and therapeutic endeavor that each and every one of us has the ability to undertake. The insight and the joy derived from just a few minutes a day of writing brings with it inner peace, self-realization and a better understanding of ourselves, and of the world in which we live. So take a few moments today and everyday to share your thoughts, share your words, and let the pulse of your spirit fall upon the page.

SOUL SONGS

Old Detroit by: Christy Pardee

Christy Pardee is an Artist, Poet and Painter Currently studying for her Masters in Art Therapy at Wayne State University.

Poems by Thasia Ann

I AM

I am the willow tonight
and I weave to the
music of the warm breeze
I am the melon waiting
to be tasted
The warm honey
sweetness
that I am

Rivers wish to be me
and the trees hope to be
so strong
I do as I must do
and granite tries to be me
I am proud

I am powerful
And only you know my
weaknesses
For I do not have any
except for the sanctity of
your acceptance

Arrival

I held my head down low for so long
I found it difficult to look up. I was covered with cob webs of despair and leaves of brittle nerves to brush off I couldn't rush off but I did put one foot in front of the other. He couldn't smother my soul

He couldn't control the little voice inside that whispered to me

He's wrong
And you are somebody

And you are on your way to somewhere

And well Here I am

I have arrived!

Thasia Anne is a 59 year old great grandmother and social work senior at Edinboro University in North Western Pennsylvania. Her studies and her passion consist of ridding the world of domestic violence.

Thasia Anne

More about Thasia

Thasia Anne was one of the featured Poets on August 8th, 2015 at the SCCA Mosavat Gallery. Thasia brings her unique and heartfelt words of compassion for those who have dealt with domestic abuse. Her goal is to end this horrible situation for all those who have experienced it, and also to prevent it from continuing to happen. The SCCA thanks Thasia for her commitment to this cause, and for her contribution to S.O.U.L. and the SCCA.

The Art and Soul of Creativity

We're on the Web!
sourceofuniversallove.com/

MORE ABOUT S.O.U.L.

S.O.U.L. helps to transform the lives of individuals and families in adverse situations by providing support and help. Our goal is to respond with love, respect and to provide the resources we have available as needed. We support everyone who comes to us. Some of the ways we assist include; food, clothing, education, resource research, household goods, furniture, care counseling, transportation, comfort and compassion. We help the homeless, abused, those in medical crisis, and people transitioning from divorce and other hardships such as a loss of employment. We strive to provide solutions which enable people to return to a self-sustaining status.

Contact Us:

> Source of Universal Love
> c/o Ginger B. Wiechers
> P.O. Box 5
> Farmington, Michigan 48332-0005

> www.sourceofuniversallove.com
> soul_nonprofit@sbcglobal.net
> (248)318-6691 ♥ (248)672-0616 ♥ (248)682-5912

On May 27th, a call went out for submissions to Soul Songs Magazine.

We asked for poetry and prose pieces. On the following pages you will find the excellent writings of Chris Feldt, Rose Marie Wilson, and more.

We at S.O.U.L. and the SCCA convey our heartfelt thanks to these artist who have taken their time and their talent to submit their amazing pieces of work.

Creativity is the light that shines within us all and these artists are beacons of hope and insight.

SOUL SONGS

Chris Feldt:

40 year old native of Michigan. Veteran. College graduate. Writer, philosopher, composer, pianist. Lover of cats and foxes. Internet Technology Officer working at one our nation's largest tanneries.

How Many Walk Among Us?

How many walk among us
that we don't even know?
The reclusive Picassos
and downtrodden Van Goghs,

The sequestered savants
and homeless heroes,
hiding in plain sight
while thinkin' they're zeroes.

The Robin Williams that never was,
The Vaclev Pavel afraid to write,
The Michelangelo of the street and
Da Vinci of the Night?

How many walk this planet
Pretending they're not on it?
Please enrich our world
with brush, with song, and sonnet.

The Menagerie

Within each of us are dark places,
caverns of pain and loss
of fear and insecurity,
where we cautiously explore
the depths of our burrows
making mysteries intelligible
and our secrets known,
by bringing each artifact
into the light of day
and illuminating a complete
diorama of ourselves,
thereby filling our galleries
with reclaimed thoughts:
our museum of antiquities
our menagerie of memory.

Entomophily

She is the closest I've considered to be everything. Each part of her, each petal colored differently than the next, shaped unlike every other, wildly beautiful, earthy and magnificent. Sadly, yet realistically, like all paragons of nature, her intensity is lost upon the quotidian wayfarer, not beheld by the distracted. Oblivious as the flowers themselves, she too is unaware of her own seductive power. But not to the bees. For like the bees, I too am drawn to her nectar, her warm center, beauty and color....waiting to hover over her to partake in our fated dance; a primal choreography of unquenchable desire.

Rosemarie Wilson aka One Single Rose

Rosemarie Wilson a.k.a. One Single RoseTM is an award winning poet, spoken word artist, singer, actress, playwright, author of two self-published poetry collections and a naughty chapbook. Rosemarie is a Davenport University graduate, five time National Poetry Award (NPA) nominee, 2010 recipient of the NPA's New & Upcoming Poet and Poetry Author of the Year awards, four time Who's Who in Black Detroit honoree, first place and two time honorable mention recipient of the Detroit Writers' Guild Paul Laurence Dunbar Poetry Contest, 2012 SAFE (Sisters Acquiring Financial Empowerment) Ambassador Award recipient, SVMixMedia.com's 2012 Performance Artist of the Year, Detroit Metro Times' reader's choice 2014/2015 Best Local Poet and she was nominated in the 2014 Spoken Word Billboard Awards. Upon entering a slam competition for the first time at the Motown Museum in Detroit, Rosemarie was named Motown Mic 2014 Performance Artist of the Year. In 2011, Rosemarie debuted as an actor in Detroit. She has since performed both nationally and internationally in a few amazing productions. Her works are available worldwide in various anthologies, publications and websites. Rosemarie also hosts open mic poetry every 1st and 3rd Friday in the Spotlight at Manila Bay Café, which was named 2014 Open Mic of the Year by the NPA's and Detroit Metro Times' reader's choice 2015 Best Open Mic, located at 4731 Grand River in Detroit, Michigan. 2014 marks the official launch of her non-profit motivational workshop series One Single Roses BloomTM, workshops centered on inspiring bright young STARS and seasoned adults to fearlessly follow their passions. 2014 was a year of "firsts" for Rosemarie—she released two spoken word cds, (Poetic Truth available on iTunes and Straight Up, No Chaser) and her first full-length comedic stage play entitled ADDICTION sold out in its debut at the Boll Family Theater, on Broadway in Detroit. For more information on One Single RoseTM, please visit www.onesinglerose.com.

Unbreak My Heart 5-28-14-
A Tribute to Maya Angelou

My heart broke into pieces on the pulse of morning
stopping briefly upon receipt of breaking news that you'd transitioned.
I pray that your wings fit you well
while your soul finds amazing peace.
Even the stars look lonesome now
as the caged bird sings your praises;
its song flung up to heaven
by way of the moon on a rainbow shawl.
You were mother courage,
a fearless bird
blessed with a quick witted
slick tongue that spoke brave yet startling truths.
You wrote that I'm a phenomenal woman,
one of many women in business,
so I believed you.

I tried.
I stumbled.
I fell,
but still
I rise
realizing I've come too far by faith.
I just can't give up now.
Failure is not an option.
I wouldn't trade nothing for my journey now.
All God's children need traveling shoes
to run away on the long road ahead.
Someone is gon' give me a cool drink of water 'fore I die.
Know that I shall not be moved
nor will I look away
until I'm touched by an angel.
From a black woman to a black man,
to all of my brothers and sisters,
this life doesn't frighten me.
Optimistically, I believe change gon' come.
So, let us fight this cabaret for freedom
gathering together in the name of Maya Angelou.
Her poetry unbreaks my heart.
Her legacy embodied the heart of a woman,
the least of these,
the best of these,
down in the delta
or on the stoop at Brewster Place.
Soon I'll be singin' and swingin'
and getting merry like Christmas,
stayed on my mind;
happily engulfed inside celebrations,
rituals of peace and prayer
in remembrance of the mom in my head
whose pen pushed love for us all.

-Rosemarie Wilson aka One Single Rose
©2014

Eyes Back to Basics

Intriguing eyes as rivers to swim
Deep blue as the sea
Clear as the aquamarine sky
Coarse as a brown beaver
Smooth as dark chocolate
Black as coal and dark as night
Shining full of power and light
Green as pastures and the Chicago River on March 17
Yellow as sunflowers melting like butter
Truth comes forth while gazing into these eyes
Emanating from a vast place where goodness subsists
Eyes sparkle like diamonds on a sunny day
Glisten like gold worn by kings and queens of yesteryear
Crimson when angered
Calmed while scarlet letters are corrected
Stars fill the retina with bright ideas
Pools of sadness bag when things aren't quite right
Clouds fail to deter as the dolphins dance
Fireworks spark through the pupils
Exciting minds with every color of the rainbow
Whites pure as freshly fallen snow
Emerge fierce as a polar bear when threatened
At dusk eyes become as carroty as the sun
Hanging onto the promise for tomorrow

-Rosemarie Wilson aka One Single Rose
©2009

Bozena Helena Mazur-Nowak comes from Poland but since 2004 lives in UK. She considers herself as a poet. She published six issue of poetry. Four in Polish and two in English. She is also a contributor to numerous anthologies worldwide. In 2014 she tried herself in prose and published her very first novel "Blue Cottage".

Dilemmas of the Heart

Each night I return to those green fields
To the fragrant linden trees, willows with the outstretched arms
I count, up there in the sky, storks arriving with the Spring
And in my mind, I circle around my grandmother's cottage

I listen to the brook babbling in the morning
And to grandfather's violin playing in the evening
I bring my entreaties to the roadside chapel,
To allow the pilgrim to return with a bowed head

Each night, I return from a distant land,
To where you can hear the wonders of Chopin's playing
To the fragrant fields of Mickiewicz's stanzas
'Dabrowski's Mazurka* will remain in the heart * Polish national anthem.

Ticket to the Happiness Station

In front of the ticket office the queue is long, as usual,
I turn a coin in my hand and wait.
Cashier winks at me amicably.
'Where would you like to go'?

I look around with abashment.
'You are holding up the queue'- someone urges
'Can I have a ticket to Happiness Station, please'?

A blonde standing behind me laughs loudly,
'Would you listen to her! Ha, ha!'

'So what about the ticket'? - the cashier asks again
'Happiness Station, please'-I repeat shyly

This time the lady at the ticket office loses her patience.
'Go have fun somewhere else, lady – she barks at me'
Young boy wearing wire-rimmed glasses looks at me sympathetically,
the only one in the long queue.

I squeeze the coin tightly in my hand and walk away.
I leave the station and walk along the river.
I hear beautiful music coming from a moored barge
I stop for a while to listen to the lovely sounds.
'Happiness must live here'- I think.

I kiss the coin in my hand and throw it in the river for luck.
I will come back here again. For sure, I will.

<div style="text-align:right">-Bozena Helena Mazur-Nowak</div>

Brittany Farber

Bio

A graduate from Michigan State University with a Master's degree in Speech-Language Pathology, Brittany provided Speech and Language services for many years before making the decision to stay home and raise her 3 young sons. What began as simple and inspiring entries in her journal, developed into intuitively and divinely guided messages with poetic flow. When she is not retrieving angelic messages of hope, she may be found outside or in the lake playing with her beloved husband, children and dogs in West Bloomfield.

Reunite

Swimming in a sea of blue green windows,
Stardust glowing beyond edges of your sphere.
Title wave of love as universes appear.

Exposing light reaching all senses,
Faces but shadows concealing mastery of oneness.

Wheels spinning from root to crown,
Unlocking centuries of secrets bound.

Floating, rising…a collective match,
As gardens sparkle and curtains detach.

Revealing the truth surrounding our now,
A tapestry of love reflecting every vow.

Nature singing and radiating joy,
Encapsulating the beauty two souls employ.

Discovering the truth in one exchange,
Beyond time and records our bond remains.

Love spanning worlds and bliss beyond place,
Comes together in this moment I see your face.

Chords

Between where you stand and my heart beats
Is a chord transmitting our life force of heat.

Pulsing in rhythm of your intent,
Infinite exchange of every moment.

My love is yours and yours mine,
Our wisdom, our truth intertwined.

Beyond what we see and what we feel,
This invisible chord is undoubtedly real.

Connected by truth and sealed with love,
Our ethereal chord brings blessings from above.

If you feel fear I will send light.
When I am lost, you shine through bright.

As chords retract and we are at last near,
Attached with love and never fear.

-Brittany Farber

SOUL SONGS

S.O.U.L Apparel for Sale...

Unconditional Love

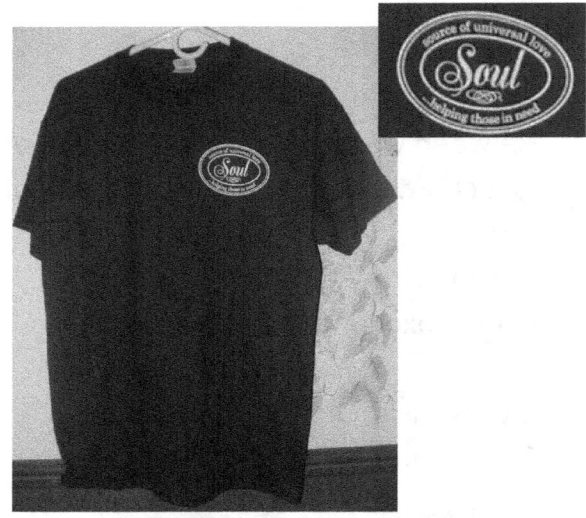

Serve Locally Love Globally

You aint styling unless you have your S.O.U.L. On!

Contact us and order today!

T-shirts	*$15.00*
Crew Sweatshirts	*$32.00*
Pullover Hoodies	*$36.00*
Full zipper Hoodies	*$40.00*
Baseball Hats	*$24.00*

*plus tax

To order call (248)672-0616
Email: soul_nonprofit@sbcglobal.net

Thank you, your support is appreciated!

The SOUL Community House and LULU.com
Book Collection

The Art and Soul of Creativity

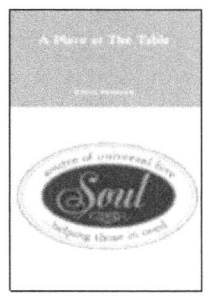

A Place at The Table By William Burkholder
Paperback: $12.95
Ships in 3-5 business days.

The following pages are a culmination of meditations and writings by William Burkholder. In this volume it is offered in a rambling fashion so that the reader can more closely identify (hopefully) with the human thoughts processes that some may have and exercise. It is through these thought processes, these ramblings of thought that this volume, "A Place at the Table was born. These pages consists of various works written between 2007 and 2015. It is the author's fervent opinion that each of us who reside in this world have a place at the table of humanity. It is up to us as humanitarians to ensure that no one is left without food, without love or without security of their person or dignity.

A collection of works from Poets around the world who have committed their time and talents for a worthy cause in supporting the Source of Universal Love, a 501(c) 3 nonprofit organization.

My Journal of Reflection and Restoration
By Source of Universal Love
Paperback: $11.99
Ships in 3-5 business days.
☆ ☆ ☆ ☆ ☆

A journal to be used for your inner journey of discovery and restoration. That through your thoughts and meditation you can grow beyond your expectations and share with the world your inner most thoughts and beauty.

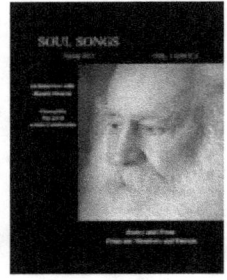

Soul Songs
By Source Of Universal Love SCCA
Paperback: $10.00
Ships in 3-5 business days.
★ ★ ★ ★ ★ (1 Ratings)
The first issue of SOUL Songs an SCCA creation for SOUL, highlighting the creativity and charitable efforts of Source of Universal Love.

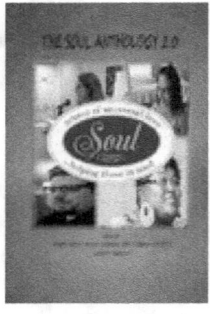

Version 2.0 of the Soul Anthology series featuring world class poets from around the globe. Special thanks to those Writers who have committed their artistic efforts to help those in need, via the non-profit charity, Source of Universal Love (SOUL).

Soul songs is honored to provide an interview with our Executive Director, Ginger B. Wiechers, she is the spark that keeps the fires of giving and compassion burning. Please read, enjoy, and learn a little more about Ginger, and the Source of Universal Love.

Soul Songs: Tell us about S.O.U.L.?

Ginger:
S.O.U.L. is a 501(C)3 non-profit corporation... dedicated to helping people in need. This organization helps to transform the lives of individuals and families in adverse situations by providing support and help. Our goal is to respond with love, respect and to provide the resources we have available as needed. We support everyone who comes to us. Some of the ways we assist include; food, clothing, education, resource research, household goods, furniture, care counseling, transportation, comfort and compassion. We help the homeless, abused, those in medical crisis, and people transitioning from divorce and other hardships such as a loss of employment. We strive to provide solutions which enable people to return to a self-sustaining status. Please visit our website at www.sourceofuniversallove.com.

Soul Songs: The organization is completely volunteer based. Is that correct?

Ginger: Yes, for almost a decade there have been a core of the most dedicated and committed volunteer staff. Additionally, over the years there have been so many people who have contributed their time, interest, hard work and sincere desire to help make a difference. S.O.U.L. is so grateful to each and every person who so kindly give of themselves.

Soul Songs: You have other work that you do and I'm sure much time is devoted to S.O.U.L. You also see a lot of sadness and despair. How do you "Stay Calm and Carry On"?

Ginger: I would have to say that it comes down to gratitude. It is a humble experience to be privileged to truly serve others in their time of need. I take this responsibility with the utmost sincerity and a heart filled with gratitude that with the help of so many we can answer the call for assistance.

Soul Songs: Any other guidance on this topic?

Ginger: Yes, balance. For all who are "wired" to give, to serve others, to be a caregiver and so on this is an important topic. It is essential to balance yourself with quiet time, nature and radically good self-care. Working out, yoga, meditation, massage, proper nutrition are a few examples.

For me balancing the responsibilities I have personally with those of being in services to others brings deep satisfaction and inner peace.

Soul Songs: Do you have a message you would like to share?

Ginger: Recently I wrote an article, "Call to Action". I feel very passionate about this topic. There's so much profound need in the world. Whether it's feeding the hungry, providing shelter for the homeless, caring for neglected and abused animals or doing our part to help the environment, I feel we must step up. We must care more deeply. We must move beyond the feelings of sadness, thinking we can't make a difference and Take Action. How do we do it?

There are unlimited ways. Contact S.O.U.L. or any non-profit organization that you feel drawn to and ask how you can help. Contribute monetarily or donate clothing, food, and household items. Have a bake sale. If you're having a party or celebration, in lieu of gifts ask for donations to your favorite charity. The list is endless. I feel we all have a responsibility to help one another. We can give our love, time and resources. For those who feel they are not in a position to give, I would suggest a smile, compliment or any kind words. These simple gestures can lift someone's spirit and brighten their day.

Soul Songs: What advice would you give someone if they are feeling sadness, despair or even hopeless about their situation.

Ginger: There are many ways to address this.

* Talk with a trusted friend, counselor or religious advisor. My mother always said; "what people need most is a good listening to". I believe it's very therapeutic to be able to share, be heard and acknowledged. Additionally, if requested, ask to hear another perspective or advice.

* Go to a library or bookstore and seek books that are uplifting and inspirational. The more we surround ourselves with positivity the greater our chances to change our feelings and outcome.

> "We can complain because rose bushes have thorns
> or rejoice because thorn bushes have roses."
> -Abraham Lincoln

*Go for a walk in nature. Have a picnic in a park. Nature soothes the Soul.

*Listen to music and enjoy the calming, soothing, healing qualities. For me, music has always spoken to me. Songs that comes to mind that inspire and remind..... Mariah Carey's "Make it Happen", Calling all Angels" by Train, India Aries', "It's the Little Things".

> "There's no greater reward than working from your heart
> and making a difference In the world."
> -Carlos Santana

Soul Songs: Any final words?

Ginger: People often say to me that they're trying, yet there not making much of a difference. To this I respond by quoting Yoda (Star Wars): "Try, try not, do, do not. There is no try, so do. In conclusion Nike says it best, "Just Do It"!

Ginger B. Wiechers, Executive Director
Source of Universal Love

The Poetry of S.O.U.L.
An anthology of selected works
from Poets around the world.

A 2015 SCCA Publication,

http://www.lulu.com/shop/source-of-universal-love/the-poetry-of-soul/paperback/product-22206186.html

SOUL SONGS

Get them while they Last, SCCA t-shirts now available!

Just $15.00 each available at the SCCA Mosavat Gallery!

(734)634-0162

Email: scca59@gmail.com

SOUL's IMPACT ON VOLUNTEER YOUTH

Throughout the years, I have been blessed to have my two daughters involved with the charity, Source of Universal Love (or "S.O.U.L."). S.O.U.L.'s Executive Director, Ginger Wiechers, has fostered many opportunities for my kids, as well as other kids to participate and make a difference in someone's life.

They have been fortunate to bus tables at one of the "Thanks for Giving" dinners, help to run "free store" at the annual holiday party, assemble some backpacks with school supplies, donate garage sale proceeds, help me fill a long holiday shopping list for a family in need, and recently, donated their bike to a woman in need .

As I write this, they are collecting returnables and more garage sale items in order to donate the proceeds to S.O.U.L. Can you tell that I am proud of them?

RUSS BISINGER
SOUL SONGS
STAFF WRITER

One of the best parts of their relationship with S.O.U.L. is the connections that Ginger intentionally strives to make between the volunteers and the recipients. A good example is the smile of someone in need when my girls brought them a desert at a charity dinner.

Another good example comes with the very moving stories that Ginger shares regarding the circumstances of an assistance request. Also, although it is never needed, Ginger always takes the time to thank my girls for their help. All of these important connections have helped to add value to the whole experience of working with such a high quality charity like S.O.U.L.

In addition to the good volunteering for S.O.U.L. does for those in need, it has improved my kid's life in an unexpected way. Being made aware of such dire needs has most certainly made them appreciate our modest existence more. It really helps to put things into perspective when you see someone in need of constant medical care and you're worried about not having this year's latest electronic device.

Volunteering for S.O.U.L. has helped my daughters develop and define their own humanity. Too many youths go through life without such an amazing influence as S.O.U.L. I am forever grateful for the positive influence of S.O.U.L. on my kids.

SCCA Staff Writer
and Proud Father,
Russ Bisinger

The Passion to Teach

By Contributing Writer: Jodie Conerly

Jodie Conerly is a Sociology professor at Macomb Community College.

"In order to serve, we must be socially aware."

Recently I was asked by a good friend to write an article for SOUL magazine. While, I was overwhelmed with the idea the thought of a specific subject matter proved challenging. I pondered for a while and settled on the topic that matters most to me the subject of Sociology. Sociology is defined by (Merriam-Webster dictionary) as the science of society, social institutions, and social relationships; specifically, the systematic study of development, structure, interaction, and collective behavior of organized groups of human beings. I've been both a student and Professor of Sociology for quite some time. The subject is near and dear to me as we witness numerous changes in our world, environment, relationships and society overall. I've been teaching Sociology for eight years now at Macomb Community College it has not only become a passion but a way of life.

Many students enter my classroom unaware of any aspect of the field of Sociology, but leave with a new awareness of relating not just their personal day-to-day experiences, but applying various concepts when dealing with social and/or world issues. Throughout the years I've developed a "teaching philosophy" incorporating these concepts that not only the students use, but I utilize as well. I'd briefly like to describe some of the tools that help me and my students succeed. These tools help my students leave their Sociology class as more active and informed citizens fully aware of the complex nature of our ever-changing society.

First, students need to feel welcome. This is done by creating an atmosphere conducive to learning. A safe, supportive classroom where students not only feel welcome, but enjoy coming to class. This is done by welcoming students to the classroom, greeting them by first name, establishing clear boundaries and expectations, and being accessible by phone, email or in-person. Students must understand how the information in class will benefit their lives and futures. This is accomplished by encouraging them to understand the importance of learning the classroom material, and to take responsibility for making sure the instructor provides them with the necessary tools and strategies to be successful.

Secondly, I feel it is important to recognize that not all students learn in the same manner. A variety of teaching methods should be utilized to teach. These techniques include power-point presentations, classroom discussions, videos, group activities, multiple-choice, essay and/or true-false testing. As an instructor it is my responsibility to find out if any special accommodations are needed to assist particular students (ex: note-taker, oral testing, peer tutoring etc…).

Third, I feel it is important to adjust assignments to meet the needs of the particular classroom of students. As an instructor, it is vital to be prepared as well as adjustable to change. My ultimate goal of teaching is to assist a group of professionals by utilizing their strengths and the information they learn in the classroom to apply to their everyday lives and/or future careers.

The Passion to Teach
By Jodie Conerly
(continued):

Fourth, I believe as an instructor I also play a role as a student. I love to learn and consider myself a lifelong student. I learn as much, if not more from the students as they do from me. As an instructor it is my job to constantly research and become aware of new technology and information available in my field, our subject matter. This new information is passed along to the student(s). I incorporate these new practical tools to supplement materials from the book as they become available.

Finally, it is vital to obtain feedback from the students and incorporate that feedback into lesson plans. This strengthens the program and allows the students to get the maximum benefit from classroom learning. In closing students should also be able to obtain feedback from their peers. This method enhances learning and builds their skills preparing them for future success.

The field of Sociology plays a large role in many of the decisions we see today with regards to public policy, conflict, and social movements. It is my hope that students will leave my class more confident of their own personal identity, more free to express their personal beliefs and values with confliction, understand the role they play in society and appreciate our numerous cultures, lifestyles and choices (Plashnet).

Teaching is truly a passion for me and I look forward to the start of each semester. New students entering the classroom eager to learn, with fresh ideas, various perspectives and most of all hope! I've found my passion….

www.merriam-webster.com/dictionary/sociology
www.plashet.newham.sch.uk

SOUL SONGS

The SCCA / Mosavat Gallery is located at:

32905 Grand River Ave.
Farmington Michigan 48336

www.sourceofuniversallove.com
scca59@gmail.com

AVAILABLE AT…

http://www.lulu.com/spotlight/SOUL2015

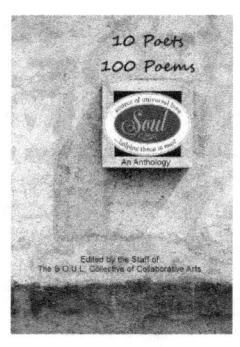

♦ S.O.U.L.'s THIRD ANTHOLOGY ♦

Released August 2015

- Personalized attention
- Dog & Cat Grooming
- All natural shampoos
- Cage free environment
- Offering holistic dog food and treats

**34559 Grand River Avenue
Farmington, MI 48335
(248)474-PETS (7387)**

NOTES FROM THE ABANDONED ORCHARD OF THE MOON" By: Marc Creamore

EDITORS NOTE: This interview was conducted in 2008 by Nirvanasgate.com and has been reproduced here for Soul Songs Magazine. With the permission of Nirvanasgate editorial staff.

Marc is a dynamic talent living in Vancouver British Colombia. This newest publication is the fifth work that Marc has published. Other titles include "The Wrong Side of the Curtain, Corridors, Bleaker Street, and Tea Leaves and Denim.

Nirvanas Gate has been granted exclusive access by the author to conduct an interview to discuss his writing and his newest book. Needless to say, we are thrilled to have this opportunity to discuss the art and craft of poetry with this fine North American writer.

Soul Songs:
Marc, it is a sincere pleasure to have you with us today. Thank you very much for taking the time to discuss your newest book with us. Marc I have had the pleasure of reading your work and I am fascinated by your style and your ability to render such visualistic pieces.
Can you talk to us a bit, of how you got your start in writing poetry

Marc:
My formative years were the late 60's and early 70's. The self-expression and creativity of those halcyon times almost became a life blood of sorts for me. I had been dabbling in poetry a little earlier, in my mid-teens, but with the explosion that began to occur, particularly in the music scene, I really started to delve into poetics on a much deeper level. I listened to Bob Dylan, began reading the Beat Poets in earnest and realized the possibilities of spoken word as a means of higher expression.

Soul Songs:
Vancouver is a well-known city for its talented population. How does living there contribute to your creativity?

Marc:
That's a tough one for me to answer. I'm basically a relatively solitary person, love quietude, interacting with close friends and family, thus I have never really linked myself with any particular group. The artistic community in Vancouver is indeed quite vibrant, however I have never affiliated myself with anyone. The natural beauty of the city and the province does have a deep impact on my inner person though.

Soul Songs:
I am always interested in the thought processes and practices of writers. Would it be possible for you to share with us your process, in other words, what does Marc Creamore do in preparation for writing? Do you research any of your subject matter, or is it spur of the moment writing?

Marc:
I usually write very rapidly. I really feel that each and every one of us has an individual voice lurking inside of us and that if one really listens carefully one can bring that creative inner voice to the forefront. I make little or no changes after the initial burst onto the paper. I guess in many ways I believe in the Beat Poets approach to writing . . . once you get it down, don't alter it because that is when it's in its purist form. The only time I did any research at all was during the writing of my latest book. I have always wanted to attempt to reflect back and try to capture what I felt was happening during the 60's. Thus, I read many other perspectives in order to refresh and perhaps integrate some of the nuances of those times. The long poem "Do You Remember The Marketplace Of Dreams' is a good example of this.

Soul Songs:
Can you tell us of any influences you adhere to, Favorite Poets, writers, musicians, or artists?

Marc:
Bob Dylan, first and foremost. He made me understand that language was limitless and that you could wander down any avenue of self-expression and find riches there. Other singer/songwriters and poets that have influenced me would be Tom Rapp and Pearls Before Swine, Robin Williamson, David Tibet and his band Current 93, Rimbaud, Kenneth Patchen, Allen Ginsberg and Jack Kerouac. I also have a deep appreciation for the Asian ancients of Japan and China. Their use of understated language and meditative thought have given me much reflection over the years.

Soul Songs:
I am sure that your family and loved ones are very proud of your literary accomplishments. What role have they played in your ability to write such fantastic work?

Marc:
When I met my wife Donna in the 80's I had basically given up pursuing the poetry game. But with her encouragement I decided to give it another go so to speak and the result is 5 volumes of published work. For this I will ever be grateful, because without her understanding and enthusiasm none of this would have been possible. My younger brother Robin and George Koller have been sources of inspiration as well.

Soul Songs:
If given the opportunity, what advice would you give to aspiring poets and writers?

Marc:
Just write whatever you find swirling around inside your mind. Break every rule in the literary handbook if necessary, because a person's individual voice is his or hers alone . . . polish it and nurture it until you become comfortable with what it is that it is trying to say. Read as much as possible, philosophical texts and as much poetry as you can. When reading poetry, read it aloud to yourself and listen in quietly to your own mind, your own music, there is much value there.

Soul Songs:
The resonance of your work speaks to the higher consciousness that we all possess, but at times refuse to see. Can you relay in a few words to us, what your overall message is to the reader of your work?

Marc:
I honestly believe that at this crucial time humanity is beginning to realize that if we are to evolve as a species that we must revolutionize our thought processes. There are borders all around us, whether they be political, religious or created in the mind itself and that it is imperative that we break them down if we are ever to grow. I understand that this will be very difficult . . . we have had century after century of limiting the ability of the mind to truly explore the vast spectrum of possibilities it possesses. But if we are to survive in the future we must set aside our differences and come together in a collective spirit of compassion and deep understanding. This, I guess, is the basic premise that I have been trying to expound poetically for the last 35-40 years.

Soul Songs:
Marc, Nirvanas Gate thanks you for taking the time to chat with us today. We wish you continued joy and prosperity with all your future endeavors and wish you great success with "NOTES FROM THE ABANDONED ORCHARD OF THE MOON"

Marc:
I want to thank Bill Burkholder and Nirvana's Gate for this opportunity to express my views on the creative process. It is much appreciated.

Soul Songs: "NOTES FROM THE ABANDONED ORCHARD OF THE MOON" and Marc Creamore's other publications can be purchased at: http://www.froghollowbooks.com/

Creativity and Quiche
by Ginger

Summertime brings a lot of opportunities for entertaining. One of my favorite things to prepare is quiche. It is perfect and easy for breakfast, lunch or dinner. It can be part of a buffet table or served individually with fruit or mixed green salad.

Basic Quiche Recipe

1	baked piecrust (9-inch)
6	**EGGS**
1	cup milk
1/2	tsp. dried thyme leaves OR other herb
1/2	tsp. salt

1. **HEAT** oven to 375°F.
2. **BEAT** eggs, milk, thyme and salt in medium bowl until blended. Carefully **POUR** over filling in pie shell.
3. **BAKE** in center of 375°F oven until center is almost set but jiggles slightly when dish is gently shaken and knife inserted near center comes out clean, 30 to 40 minutes. **LET STAND** 5 minutes. **CUT** into wedges.

Variations that make quiche so versatile and excellent any time of day;

 Breakfast - add 1 cup chopped bacon or crumbled sausage. Morning Star makes sausage crumbles for vegetarian preferences.

 Lunch - add ½ cup chopped broccoli and ½ cup cheddar cheese
 or
 add ½ cup chopped spinach and ¼ cup onions.

 Dinner - add 1 cup chicken and ½ cup chopped peppers.

Let your imagination soar. There is no limit to the lovely combinations you can create that your family and guests will thoroughly enjoy.

<center>Life is Good!</center>

The Poetry of Nina Robb

Seasonal

I want spring to come

And partly don't.

Every year my body hardens

In the wrong places

And softens

Becoming more translucent

Than it was last year.

When I visit my mother

I see my faults through her skin

But it is in the past

Like a slide held up to light.

"Hello," my mother says and pulls me in

With her bony arms bent at the elbows.

"Beautiful," she says to this child of almost sixty.

She holds my cheeks as if again feeling for a fever.

With her dry hands she bends my neck

Until our foreheads touch.

She is not nearsighted

But she is finished with respectful distances.

She is ninety. She is old.

"My darling," she says. "My child.

My goodness.

My brat. My angel."

We used to make butterfly kisses by blinking.

We are eye to eye.

Hers are sharp, shining pins almost isolated

Against the pale blurry lines of her face

And mine are dilated pools of anxiety

Because this "Hello," of hers feels

Like the beginning of a long,

Uncertain goodbye.

Then she lets go.

"Very nice to have seen you," she says.

"You're late, but nice of you to come."

She kisses my forehead

But the tone is as if I'm a stranger,

A health aid, or an unwanted minor friend,

Or someone come to fix the television,

Without success.

Bewildered, she looks about her living room.

But she is not, suddenly, confused.

She knows very well who I am,

And where she is.

She has held me in her hands,

And understood me and the shock

Is that she's done.

Then she cruises along the furniture

Walking sideways like a toddler

And grabs her purse.

Her friend has come in the taxi

Which waits outside like a hand

Waiting to pull a fine thread

Through the narrow eye of a needle.

There is a luncheon, and a show,

And a political protest, and

A friend in the hospital.

Minutes of her life she has to live

Either quickly, or slowly,

I am not sure.

Goodbye, mother, I am

Not so important anymore.

Where you have gone, I can't see yet.

It's that place where moments draw out

Into infinite lines

And lifetimes snap back

Into single frames.

The tulips along her walkway are not yet hatched.

The snow is nearly melted though,

And spring will come regardless of

The winter it has always known would follow.

HAPPENINGS
AT THE
SOUL COMMUNITY HOUSE

Poetry workshops.

The Soul Community House hosts monthly literary events the second Saturday of each month.

SOUL in Partnership with the SCCA, publishes a quarterly magazine, Poetry Anthologies, and assists those writers who require help in getting their works published.

We do all this to benefit the Source of Universal Love, a 501(c)3 nonprofit organization.

Exuberance

We're done.
I've gone under the red oak
And sat below a she-robin
On a low branch
To wait with the robin
To listen to her tuk, tuk, tuk
Alarm call to her young and her mate:
The storm is coming! Find shelter!
But also she says—what a life! Isn't it beautiful?
Look how the sun's gold grows richer
The way it only can before a squall!
Watch
The sky change
To a bottomless lake
Of the darkest cobalt blue.
I wait with the tree. Every gust
Bursts blood-red petals loose.
What a waste! What senseless fragility
But also
Come here, it says!
Look at me! Butterfly, bee, bird
Stop here! Taste me!
I am not waiting for the storm.
I am waiting with the storm,
With the tree and the robin.
Trusting everything.

The tree may be split in two
By lightning, yes.
I could be struck dead,
Yes, the robin might fly off,
Yes, it will happen fast
Storm damage
Beauty gone.
It took half a decade
For me to see you
As someone not myself
And then to trust you enough

To lay my head in your lap
And let you
Hold my head, just the skull, loose on the neck,
Not that you did.
Not that you did.
Here's the first drizzle,
The ozone smell, the lightening flash,
The robin gone!—
Without my knowing when.
I find myself
Unable to get angry
And, believe me, I am trying
But here's the drenching downpour!
The thunderclap, the same feeling
Of exuberance
I've sometimes called love.

The Tomb of the Working Poet

How lovely his desires were

dropping into the world

curved and solid like the sweetest orange

or floating up like the roundest sounding bell

though he never wrote a word

what stirred within the poet

made him bow his head to the river's hymn

and raise his face to the sky

waiting for the dusky colors

of sunfall

in a closed room

with a windowless door

he cried like a baby

hungry and beating his fists

against the wall

when cadences came to him

he was that bothered

by the lack of everyday beauty

sometimes he unconsciously crafted

a poem in his head all day

while he worked his job

whistling like a slave sings Hallelujah

dropping poems in the road

on the way home

like something incidental in his clothes

sand in a clam-digger's shorts

or a wrench not his

he never knew he was a poet

never had words

for the range of grief and gratitude

for love made of fluff

city dust glowing and reproducing

in his lungs, fireflies

in the trees at night

what we can't know of him

we can't know

of all the unknown poets

in their graves

unread

unwritten.

Corporate Social Responsibility Redefined
By Contributing Writer: Sherrie M Mackenzie

Chances are you've heard the term, corporate social responsibility. Many companies are encouraging their employees to get involved in their communities by sponsoring corporate citizenship activities and supporting charitable causes. The majority of us do get involved, choosing charities that have personal meaning to us. Some take it a step further and do these activities all year round, without the company's knowledge or sponsorship.

In Judaism, the highest form of charitable giving is called tzedakah. One example is the giving of a donation anonymously, without recognition and without the recipient knowing where it came from. The greatest gift however is to provide a loan or training that will help a person get a job and eventually become self-sufficient. The true definition of tzedakah is the religious obligation to do what is right and just.

When you donate an old briefcase or a suit you can no longer wear, you could be giving a person trying to get a job, the means to make the right first impression. You are paying your good fortune forward when something no longer serves you, but can serve someone else.

It occurred to me today as I noodled on this, that we could take that mindset a step further. I fully support all that we collectively do for cancer research, Boys and Girls Clubs, Autism, Good Works, Habitat for Humanity and others. But imagine if we also decided to focus on charitable values and thoughtful consideration toward one another at work.

The term corporate spirituality popped into my head as I tried to put a name to what I was preparing to write about. The term exists, however the definition can be confusing. It's not about religious freedoms or prayer in the workplace. It's more in line with corporate integrity or ethical leadership. I'm talking about a concerted effort to always take the high road; and to act with integrity and respect toward your fellow man or woman.

Picture a workplace, still competitive, still driven towards achieving performance goals, meeting targets and making money; however the key differentiator is a standard of caring behavior paid forward and given freely - regardless of where a person falls in the corporate food chain and regardless of the likelihood of reciprocation.

While a Code of Conduct speaks to appropriate business behavior and adherence to policies, it does not guide how we treat people, nor should it. That comes from within - and is influenced by

what you experience from others. Individuals want to get ahead, get a raise or promotion and in this quest they can lose sight of what the extended team around them does to make them successful. There is a fine balance between choosing the best path for you, and becoming self-centered.

We don't become successful by ourselves and being conscious of and thankful for the help you receive along the way, is a moral imperative.

How often do you give or receive credit for an idea? Are you willing to share a new way of doing something that saves time, or do you keep it a secret so you look better than everyone else? Do you correct someone's wrong assumption about a person or situation, or let them go on with their misperception? When you hear something negative about a person, is your first instinct to join in and share similar feelings or do you question the comments and offer another way of seeing the situation?

In every waking moment you have a choice. You can challenge the status quo and take the spiritual high road or fall into the trap of feeding negativity, inequality, gossip and corporate politics. You can choose to ignore the people who don't influence your climb up the corporate ladder or you can consciously notice them. Take two minutes to acknowledge and smile at the person who makes your coffee or delivers the mail. Be thankful for the person who goes out of their way to be patient when you are having a horrendous day. Say something complimentary about a person who has impressed you. They may never know, but you would be amazed at the ripple effect it has.

When you employ these principles in your daily work life, a funny thing will happen. You will get back that which you put out. Just like a yawn is catching, a compliment is catching. Give credit where it is due and be vocal about who did the work on your team. Stop worrying what everyone thinks of you and concentrate on being a good person who helps make others shine. When you do, you will be amazed at how bright and shiny you become.

The collective tide can be changed… with inclusive, continuous, intentional acts of kindness.

Noodle on that.

A SPECIAL MESSAGE FROM OUR FRIENDS AND FELLOW POETS AT REALISTIC POETRY INTERNATIONAL

Realistic Poetry International recognizes how essential it is to support one another as artists in such a competitive, and sometimes even unkind world; and as a poets, we also understand it can be rather difficult to get people to purchase books, leave reviews, and obtain effective marketing and advertising at affordable prices. It's just as challenging to have people share posts to Twitter, Facebook, and other popular social media platforms; especially if it pertains to a positive enlightening message; often which poetry does. Most of the time, many of us are too busy with our own projects to genuinely care about our fellow peers. So, after a careful examination of the literary sphere, it is inevitable to conclude most poets and poetry companies are in it for self and personal monetary gain. It saddens me to see such a prestigious art, such as poetry, develop into a selfish, gluttonous, get-rich scheme and hustle.

It is very rare to discover an artist or a company, including publishers and agents, in this current era who do not have a dollar as the bottom line. We must ask, what happened to the candid love for the poetry craft? What happened to the true definition and meaning of support? What happened to writing poetry to help someone now, or in the future? What happened to just picking up a pen and a paper because they were the only things that would listen to you? We must ask, what happened to inspiring and motivating our peers to be and do better? Realistic Poetry has noticed, most people tend to merely support primarily the celebrities and the famous, but what about us, the *regular* artists? The everyday poet. What about the poet who wishes for success so that they may quit their day job in effort to put all of their time and energy into their art and craft? What about all of the beginners who never really get the recognition they deserve? What about you? What about me? The blame falls on each and every one of us and Realistic Poetry International is simply weary of making excuses and pointing fingers.

Truly, each and every one of us matter and all of our words play a major part in changing the world; though it can be difficult to chase a dream when you still must live. Realistically, about 70% of us struggle on a day to day basis, trying our best to balance life and our creative goals; but Realistic Poetry International is proud to say we want to support! So, allow us to be the first to step up! We will extend a true hand of support to the poetry community and we pledge to honestly help in any way we are able so that we may inspire others that are also on a positive mission, spreading the truth through the power of poetry. We have wanted to do so for a very long time now, but were financially incapable, however; as God continues to bless us, we make it our mission to give back to the world. Don't get us wrong, we are not rich at all, we are just like you. Nonetheless, we have found very beneficial resources and have gained many supporters throughout the years. On top of our persistent hard work, we have managed to put together a fund in which we plan on using to give back to the poetry community. We plan on buying poetry books and leaving reviews for selected books. We will also be helping with free promotional pictures, including fliers and posters, logo designs, business card templates, and video trailers. We are glad to critique poetry for those who are looking for an honest opinion concerning their work and we definitely don't mind sharing your work on our social networks, websites, and blog pages! This includes your new advertisements and promotions!

If you need our support in any other way, we do not mind responding to emails explaining how we can be of assistance. We do ask for your support and help in return. Let's face it, likes and shares are important when it comes to social media. Comments are also very useful to the writer as well as the audience of the poet, plus, word of mouth is one of the greatest forms of marketing! So, tell a fellow friend or a family member. Get other people involved when you see something good.

Realistic Poetry International appreciates all forms of support! We ask that you please put forth an honest effort, as we will earnestly do the same.

We do recognize that there are many artists, writers, companies, entrepreneurs, readers, and more directly, poets, who proudly strive to make the poetry community a better and more successful environment every day. Please, continue to reach out to us as we are also willing to reach out to you so that we may work together in order to achieve this remarkable universal goal! We say thanks to you all! We love poetry and we love you!

www.realisticpoetry.com
realisticpoetry@yahoo.com

EDITORS NOTE:

Delano Johnson and his Wife will be our featured guests on September 12th at the Soul Community House, where they will share their poetic mission and ideals with us. They will also be in the lineup of featured poets for the evening.

Music Lessons Done Differently

We Teach

Guitar, Drums, Bass, Piano, Vocals

Performance Based Program

22730 OCHARD LAKE RD.

FARMINGTON MI. 48336

FARMINGTON.SCHOOLOFROCK.COM

248-987-4450

You are cordially invited to hear
stories told by your neighbors and friends at

Farmington VOICES
RESILIENCE

a community story-telling event

September 30, 2015 at 7 p.m.
in the Historic Old Winery Building

31505 Grand River, Farmington

A portion of proceeds will be donated to Neighborhood House and Operation Common Good. Donations of personal hygiene items and paper goods will be collected for Neighborhood House.

Tickets $20 in advance, $30 at the door

Available at farmingtonvoices1.eventbrite.ca or by calling 248-568-0581.

STERLING SERVICES
FRESH FOOD. FRESH IDEAS. FRESH START.

WWW.STERLING-SERVICES.COM

Sterling Services was created in 1986 to provide the Metro Detroit area with a quality Vending program. Today, Sterling Services is known throughout Michigan as a leader in foodservice management and vending. With our highly customizable food programs and the latest in available technology, Sterling Services is looking forward to our next 25 years.

Let us help you provide a world class foodservice operation to your business at a minimal cost.

We are happy to provide our clients with:

- **Full Food Service Management Programs**- Our programs are proven to drive participation and turn your dining room into a collaborative, enjoyable atmosphere.

- **Event Catering**- Our chefs and staff can handle lunch meetings to large events and anything in between.

- **Fast Track Convenience Stores**- Sterling Services brought to market Fast Track Convenience, a 24/7 C-Store with Deli fresh foods in a secure environment. The best part: Fast Track comes at little to no cost to your organization!

- **Full Line Vending**- Full, Clean and working is our motto!

- **Office Coffee Service**- Let us help you find the blend perfect for you!

www.ingramcontent.com/pod-product-compliance
Lightning Source LLC
Chambersburg PA
CBHW080853170526
45158CB00009B/2720